Priya Mookerjee

PATHWAY ICONS
THE WAYSIDE ART OF INDIA

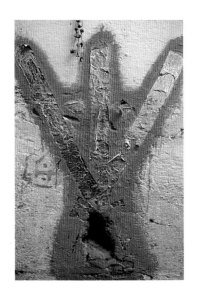

With 76 colour photographs

Thames and Hudson

Title page: the Trident of Shiva (Rajasthan)

Preface

I first became aware of the richness and beauty of pathway icons, and their symbolic significance, during my travels in India – in Rajasthan and Bengal, Gujarat and South India, and the areas around Delhi. As a painter I was struck by the variety of the richly expressive images, painted in vivid colours. These powerful forms with their subtle abstractions seemed to express in a unique way the inner quest of the artist-invocator, to touch the divine. In making this collection of photographs my approach has been that of an artist; it is a record of my personal impressions.

P.M.

Introduction

Nothing is far away,
Everything is near:
The universe
And the painting on the wall.
CHANDIDAS

In India, life, art and religion are one. The process of creating a work of art is also an act of worship, one through which the invisible manifests as the visible, and the artist who 'invokes' the image gives form to the formless, seeking to discover the unknown through the known.

The act of creation is at the same time a process of self-discovery, inspired by a desire to unite the human spirit with the divine. The ultimate goal of life is to discover the divine essence which is a part of all that exists, so that it is no longer the unknown, but becomes an intimate part of living, when the seeker and the object of worship enter into a personal and a very special relationship.

Having travelled widely in India, one begins to appreciate the important role that pathway images play in the daily life of the village. They occupy a central place in the life of the community, deeply rooted in local tradition. They are a focus combining religious beliefs, popular cults, myths, local legends and magic.

An individual who feels the need of supplication to impart a wish, whether profound and impersonal or simple and personal, makes an image using local materials such as straw or clay, bamboo or stone, or sometimes even cloth. The image is usually set on a freshly limewashed platform, often under a tree, or in a corner, or on the bank of a river. Both the image and the ground where it is placed are sanctified by rituals and the chanting of mantras – in Sanskrit 'mind-tools'. The symbol, which is a visual tool, and the mantra which is a mental tool, invoke life to enter the image.

From this moment of sanctification the image ceases to be just a piece of stone or lump of clay and becomes a living manifestation of the divine principle. What is the power that can transform a fragment of stone or clay into a divine manifestation? It is the power of human consciousness, a consciousness that evolves from a desire to reach out and pass beyond the limitations of linear time and the confines of daily human existence.

The human mind is always seeking ways by which it can escape its present limitations. Whether these limitations are sensed as a personal predicament or

4

a universal one – the human condition – the search is always to find answers. Therefore the concept of divinity evolves from within, and the numerous forms of representation are just the many different ways of self-expression. As with an artist whose conception evolves with each step until a clear picture emerges, and the final moment brings with it a sense of recognition and fulfilment, so the seeker struggles for inner transformation, until gradually a new realization unfolds.

The images that we see beside the paths are therefore a means by which we are brought into harmony with the cosmic scheme, and a personal communication which brings a feeling of release and fulfilment.

Many of the images are totally abstract, consisting of bright-coloured marks and geometric symbols. Others are two-dimensional designs with a pair of eyes inserted. Often pieces of shiny coloured foil are cut into various geometric patterns and pasted on to the surface of a rock or stone, wall or tree. Some images are figurative, with a well-defined face of a god or goddess. Often only a pair of feet or just the head of a deity is represented. The appearance is sometimes surreal, as the images glisten in the sun or are lit by an oil lamp.

Side by side with all the gods and goddesses are the ancestors. Tablets are set up in their memory, and elaborate rites are performed so that their souls will attain deliverance. Trees are anointed and worshipped, for they symbolize the cycle of growth and regeneration. Each tree has a spirit, therefore a large tree is always revered by the village community. Often a hollow is carved in the trunk of a tree and a shrine dedicated to one of the ancestors is placed inside it. Sometimes parts of the body of the deceased are buried among the roots of a tree, symbolizing the cycle of renewal.

Every aspect of daily life finds its expression, not only physically, emotionally and spiritually, but also visually and symbolically. Nature is a mirror reflecting the divine, therefore the five elements – earth, air, fire, water and space – and the sun and planets, mountains and rivers, rocks and stones, trees and animals as well as human images, are all worshipped.

Although all artistic expression is 'sacred gesture', it is at the same time, and more importantly, a means to carry individual consciousness into the universal realm, whence springs all creation. Images are not made as 'art-objects' but as channels of communication with the divine, generating a power that one seldom feels on seeing similar objects in a museum. The image-maker who seeks to embrace the vastness is not concerned with mere outward appearances, but rather with the essence, the symbolic message that takes the image beyond mere intellectual and aesthetic appeal. This is not to imply that

these images are devoid of beauty, for the subject-matter itself demands that the artist responds with great care and sensitivity.

Creative expression is both personal and shared, for the whole community can participate and respond with the fullest emotion. To make an image for the purpose of worship is a process that works on many levels, for it becomes a way of knowing the workings of the inner self, and a path leading to the converging-point of artist and mystic. In India, mythology, metaphysics and mysticism are inseparable. There is an underlying connection between the simple spiritual life of a village community and the highest philosophical knowledge of the sages, for both are paths leading to the same goal.

Everything fluctuates between opposites – vast and small, individual and shared, sacred and profane. Duality is intrinsic to nature, and creation and destruction are like the two faces of the same coin. Therefore, most images and symbols represent both the positive and the negative aspects of reality. The Trident which is a symbol of the Hindu trinity represents creation and preservation, but also dissolution. The unfolding of creation is sustained by the force of preservation, but as nothing in nature is static, it must ultimately give way to destruction, which in turn makes way for renewed creation. The cycle of creation and destruction is the fundamental law of nature; hence creation is not represented as merely positive and dissolution as merely negative. They are the two opposite ends of the cosmic ladder, with preservation as the centre of balance. This is the point of equilibrium that an individual seeks in dealing with the day-to-day problems of life. Concepts such as 'good' and 'bad', 'life' and 'death', 'saint' and 'sinner' are all relative.

The ways of worship and meditation are not ways of escaping the negative aspects of life, but rather of understanding that every aspect is a part of living; that every negative aspect has to be overcome and dealt with.

This subtle and complex interaction is very strongly present in the conception of the Goddess. The Goddess is an embodiment of the active power, as she brings forth life and all that exists. She is the cosmic Mother who bestows blessings, protects and cares for all life. At the same time, during the end of the cosmic cycle she dissolves all creation, absorbing within herself the negative aspects, thus making way for new life.

The goddess is 'Shakti', that is, the active power. If the god Vishnu dreams the scheme of the universe, then the goddess Shakti through her creative powers brings this dream to life. She activates all that her male counterpart evokes. She can be the Golden One, the Pure One and the Dark One, simultaneously or separately. The Goddess is equally revered in all her

manifestations, for each one symbolizes a particular aspect of existence. For instance, the dark goddess Kali is portrayed with a garland of skulls around her neck, holding a severed head in one hand, and with her protruding tongue blood-red, yet the worshipper does not perceive her as being solely terrible and destructive, but acknowledges that death plays an important role in preserving life. Like Kali, the god Shiva symbolizes the duality of creation and destruction – the cosmic 'play'. Popular representations of Kali and Shiva are found everywhere at the wayside.

'Mata', or Mother, manifests in many forms, symbolizing fertility and the protective powers, and this goddess, too, has her dark side, as goddess of death. In many villages, if illness becomes a cause of concern it is this aspect of the goddess which is invoked and worshipped. The Great God Shiva has many folk-forms, such as Bhairon (Bhairava) who is the guardian of the village and the power that ensures the safety of the community.

The important events of life require the making and worship of pathway images. The many rites associated with birth, initiation into manhood, marriage and death are always performed with specific images or symbols. Like the icons in the temple, pathway deities and symbols are anointed, clothed and decorated. Flowers and incense are placed before them.

To fulfil personal and communal needs, numerous subordinate and folk deities have emerged. There is Ganesha, the elephant-headed god of wisdom, who is also the remover of obstacles; Hanuman, the monkey-chief of the epic of the *Ramayana*, the hero and ally of Lord Rama in his battle against Ravana, the demon-king of Lanka. Hanuman is the patron of wandering acrobats and wrestlers, for he is believed to have possessed supernatural strength, and skills that enabled him to combat every difficult situation. Hanuman is a highly popular figure who presides over most villages and settlements.

The snake is another popular symbol, and is sometimes personified as a god or a goddess. The snake symbolizes protective and healing powers, and also safeguards the mineral wealth of the earth, and is therefore an image frequently represented among the farming community.

Local legendary heroes, guardian spirits and the village ancestors are all subjects of inspiration for the artist.

However, to enter into the significance of pathway icons one has to look more deeply, for in India, the expression of religion is more complex than simply going to a temple to pray. Religion itself is a symbolic experience, and cannot be understood without fully entering into the meaning of the symbol or image. Visual symbols can communicate in a universal language, crossing the

barriers of culture. They can express profound concepts that otherwise cannot be adequately conveyed. When changes occur in the intricate balance between inner and outer experiences, symbols too, begin to evolve and change. They are a living language of signs.

From the huge variety of symbolic expression, an individual can choose a personal deity or symbol, and follow a path most suited to his or her own nature or need. Ritual and meditation can take place in a temple or in a corner of a room, or just by the wayside. The sanctity of a space is a reflection of the sanctity of the mind, and every individual carries within himself or herself a personal 'temple' that can be erected anywhere when the need arises. An elaborate temple-ceremony with richly decked deities is no more valid than worship with a simple picture, an abstract diagram, or a stone.

Frequently, worship in India is directed to an elaborately decorated image, beside which there is a cryptic symbol or abstract form which represents the essence of the deity. When figural deities are worshipped, there can at some point in worship be a change to abstract symbols in order to convey a state of feeling. Circles, squares, triangles, spirals and ovals all represent the divine just as well as the figurative icons.

Images and symbols are tools of the spiritual life, a means to the end and not the end itself. Pathway images are archetypes that emerge from the individual consciousness, and re-enter the collective subconscious, where the members of the community respond and react. Mythical beings, gods, goddesses, heroes, animals and many nature symbols become vital entities that inspire and sustain a search for perfection. Ritual observances make the individual mind dwell simultaneously on two levels, one of outer experiences and duties and the other of the vast inner resources of the psyche. What starts as an individual experience grows into a collective, community one, and in turn releases the individual psyche. Images and symbols are a reminder that the power of transformation lies within each one of us.

Human consciousness along with human faith is a force that is capable of transforming and transcending any circumstance. Pathway images are constantly renewed and revitalized, as they emerge from a common source within the range of human expression and are re-shaped to responses that go back to the origin of creation. The fifteenth-century Baul poet Anantdas expresses this simply:

> *He gave me my life*
> *And I am his expression now.*

Notes on the plates

1 Guardian of the village, Bhairava or Bhairon, a form of the god Shiva, is a protective deity who acts as a temple doorkeeper and guards the village boundary. A Bhairava-image is found in every village. (Rajasthan)

2 Poliaji is the protector of all who pass by this wayside shrine. The square figure, made of clay covered with coloured foil, has a childlike simplicity which immediately removes any sense of fear and awe from the mind of the worshipper, making it intimate and approachable. (Rajasthan)

3 Wayside Bhairava and Mother Goddess shrine, where the Bhopa (shaman) performs various rites to ensure fertility, cure illnesses, predict events and give advice concerning crops, cattle or any other matters affecting the village. On the altar are articles required for the rituals, such as a bell, a conch-shell, an incense-burner and a brass pot filled with holy water. There is also a photograph of the Bhopa's guru and pictures of various gods and goddesses. (Rajasthan)

4, 5 Wayside Bhairava shrines. Blocks of stone are smeared with vermilion paste. The shrine illustrated on the right is hollowed-out at the front. (Rajasthan)

6 Bhairava shrine with the Trident of Shiva. (Rajasthan)

7 Image of Bhairava in a wall-shrine, representing all the attributes of Shiva: the three stripes symbolizing creation, preservation and dissolution, and the two halves depicting the positive and the negative energies in creation, thus becoming 'all in one' – an image of unity. (Rajasthan)

8 A folk-form of Shiva stands guard, keeping an eye on the activities of the community.

9 An altar covered with foil is an abstract design dedicated to Bhairava. He plays many roles according to time and place, but he is always considered the protector. He protects not only the village and its inhabitants, but other gods and goddesses as well. Devotees make obeisance to Bhairava before entering the main shrine. (Rajasthan)

10 A large boulder with a Bhairava-image and patches of silver foil is a shrine where newly-wed or childless couples make offerings. Each square patch is an individual offering. The square, a symbol of the earth, is female, and the rectangular image with eyes inserted is male, a folk-form of Shiva. Without the two eyes an image is not considered to be a living entity. The eye brings the passive, that is the image for worship, and the active, which is the worshipper, into a state of mystical union. (Rajasthan)

11 Bhairava shrine with striped silver and red foil, worshipped for protection and safety. (Rajasthan)

12 A rock has pieces of coloured foil pasted over it, each piece an offering made by an individual to bring about the fulfilment of a wish, such as the birth of a child, the cure of an illness, the welfare of the family, cattle, crops, etc. The rock rises out of the earth which is considered to be the primordial mother. (Rajasthan)

13 Abstract imagery in a Bhairava shrine. (Rajasthan)

14 Bhairava shrine with figurative Shiva-images and his Trident symbol. (Rajasthan)

15 Wayside altar with ritual stones dedicated to Bhairava. (Rajasthan)

16 Ganesha, the elephant-headed son of Shiva and the goddess Parvati, is among the popular gods worshipped throughout India. He is the lord of the tree-spirits, the embodiment of success, prosperity and peace, but above all he is the remover of obstacles. His elephant-head symbolizes the strength and wisdom with which he uproots the ignorance that obstructs the path of liberation. His body is that of a child, which makes him both lovable and approachable. This curious combination springs from various myths surrounding him, the most popular being that Parvati, while bathing, wanted to dissuade Shiva from approaching her, and so created Ganesha from her sweat and appointed him doorkeeper of her inner apartments. When Shiva sought admission, Ganesha, who was unaware of Shiva's identity, denied him entry. This enraged Shiva, who ordered one of his *ganas* – 'attendants' – to behead Ganesha. Finally realizing his mistake, Shiva repented and vowed to replace Ganesha's head with that of the first creature he encountered, which happened to be an elephant. Hence, Ganesha became the 'elephant-headed one'. (Gujarat)

17 Priest offering incense before Ganesha, the remover of obstacles. Above the image is the Trident, the symbol of Shiva. (Gujarat)

18 The base of a tree is transformed into a shrine, with the Monkey-god Hanuman on the right and Ganesha on the left. The surrounding patterns follow the natural lines of the trunk, making them a part of the living tree. A raised platform demarcates a sacred space around the shrine. Symbolically, the shrine stands for protection and prosperity. (Rajasthan)

19 The beehive-shaped icon is a protective spirit who guards the entrance to a temple-courtyard where wrestlers build their strength before their patron, Hanuman the Monkey-god, who is invoked for his strength, courage, and loyalty to Rama in his battles against the demon-king Ravana. The reddish-orange colour symbolizes the element fire, which in this instance is the dispeller of darkness, and which with every kindling is born anew, remaining forever young. Each colour has a corresponding sound. The seed-mantra (sacred syllable) of red is *Rama*, the mantra of Hanuman. (Rajasthan)

20 A foil-covered stone slab of Hanuman stands as the guardian spirit of the village. Hanuman, the heroic figure from the epic of the *Ramayana*, is well known for his courage, wisdom, strength, devotion and asceticism. He is a very popular deity, and presides over every village and settlement, for without him no place is considered established. (Rajasthan)

21 Rock-carving of Hanuman holding a mace in one hand and with the other raised in a gesture of blessing. Above his head are the solar and lunar symbols, and below is placed the stone Shiva-linga which is the abstract form of Shiva, symbolizing the cosmos. (Rajasthan)

22 Foil cut-out of Hanuman with arms raised in a protective gesture. This shrine stands by the roadway and offerings are made by travellers. (Rajasthan)

23 Hanuman stands with both arms raised in a gesture of protection, and with a mace by his side which is a symbol of power and strength. (Rajasthan)

24, 25 Left, an image of Hanuman is placed at the entrance to the main shrine of a temple; right, a Hanuman shrine stands in a courtyard used by wrestlers. (Rajasthan)

26 Hanuman-image emphasizing strength and power. (Gujarat)

27 Altar dedicated to Hanuman, the 'heavy-jawed one'. (Rajasthan)

28 A head of Hanuman between two maces, with the sign of *Rama*, mantra of Hanuman, on his brow. (Rajasthan)

29 Rama, descendant of the solar dynasty, is the central figure of the great epic, the *Ramayana*. He was the eldest son of King Dasharatha of Kosala, with its capital the city of Ayodhya. Due to a plot by Kaikeyi, one of the King's four wives, Rama and his wife Sita were exiled from his kingdom to spend fourteen years in the Dandaka forest. Kaikeyi declared her son Bharata the heir to the throne. Bharata, however, resigned the throne to his beloved brother, Rama. The subsequent episodes of Rama's life are told in the verses of the *Ramayana*, whose author was the great sage Valmiki. Rama is described as a prince whose great beauty is 'moon-like'. He is courageous, and overcomes all misfortunes with dignity and forbearance. He is a skilled warrior who defeats the demon-king of Lanka, Ravana, in battle. Rama represents the ideal of a Golden Age: he is well-versed in the art of military science, law and the arts; he epitomizes the wise and just ruler who governs his kingdom with great compassion. He is regarded as an avatar or divine incarnation of the Great God Vishnu.

A village shrine depicts Rama seated with his hand raised in blessing. The heart of the image is illuminated with a piece of rectangular foil that reflects light and creates a point of focus. (Rajasthan)

30 Hanuman shrine covered with foil. (Gujarat)

31 A courtyard wall has a mud-relief of Rama, the hero of the *Ramayana*. Each year, during the festival of Navaratri, 'Nine Nights', the return of Rama to his kingdom after fourteen years in exile, during which he killed King Ravana, is celebrated as the triumph of good over evil. (Rajasthan)

32 Vishnu-images stand facing a Shiva altar. The Great God Vishnu, 'the preserver', is depicted with four arms, holding a conch-shell, a disc, a mace and a lotus. The Shiva-linga rests on a yoni base, surrounded by a coiled snake representing the creative and generative energies. (Gujarat)

33 Shalagrama, an oval stone regarded as a symbol of Vishnu. It represents cosmic energy and the creative powers of the universe. It is believed that the power of Vishnu can assume any form, and therefore this stone condenses all the attributes of Vishnu and is pervaded by his presence. (Rajasthan)

34 Shrine of Vishnu, the preserver of the universe. (Gujarat)

35 Chir-Ghat, the spot where Krishna stole the clothes of the cowherd-girls (gopis) while they were bathing in the river. It is usually women who offer a piece of clothing to Krishna, with a prayer to make their devotion to Krishna as selfless as that of the gopis. By tying the offering to a branch of the tree they symbolically free themselves from shame, fear and attachment, and re-establish their own link with the divine. (Vrindavan)

36 Having stolen the clothes of the cowherd-girls, Krishna is seated in the Kadamba tree, which symbolizes the ascent to a higher plane of consciousness. Playing his flute, he attracts all to himself. The significance of his stealing the clothes of the gopis is that we are all naked before Krishna the divine power. Here nakedness is given a spiritual meaning, as none can reach him unless freed from shame, fear and attachment. (Vrindavan)

37 A roofless enclosure is dedicated to Krishna, who stands by the entrance playing a flute. Krishna in this posture is known as Hari, the stealer of hearts. He entices all towards him with the melodious sound. This wayside structure is surrounded on all sides by high walls isolating the worshipper from the outside world, but it is open to the sky. (Gujarat)

38 Guardian angel made of papier-mâché suspended over a mobile wayside goddess-shrine. (South India)

39 A group of foil-covered images represents the fertility or Mother Goddess. There are numerous names and forms by which the goddess is known. Mata (mother) is added after the name indicating a particular aspect of the goddess or the place where she is worshipped, such as Indergarh Mata, Iya Mata. Avari and Bayasa Mata are both curers of children's diseases. Chamunda, Amli, Piplaj, Ambav, and so on, are names given to the various tribal goddesses. (Rajasthan)

40 Fertility goddess worshipped by childless women. (Rajasthan)

41 An abstract form representing the Goddess and all the female powers, decorated with red, symbolizing the life-blood. (Rajasthan)

42 Goddess shrine decorated with garlands of flowers. (Rajasthan)

43 Wall-painting depicting the Goddess, or Shakti, in her Chamunda aspect. Chamunda is one of the fierce forms of the Great Goddess Durga. She was created from the forehead of the Great Goddess to destroy the demons Chanda and Munda, hence the name Chamunda. The tiger is her vehicle, and stands guard at the entrance to the innner sanctuary of a Shiva shrine. The dog is sometimes associated with Bhairava (popularly known as Bhairon) and serves as a doorkeeper to the temple. (Rajasthan)

44 Pitha, or sacred site, used for various ritual offerings to the Goddess to ensure fertility and the general well-being of the individual, the family, the livestock and the village. The enclosure made of whitewashed mud-bricks has a small opening which symbolizes the passage from the profane to the sacred realms. (Rajasthan)

45 A stone covered with vermilion powder and silver foil is a goddess symbol, worshipped for the fulfilment of a wish. (Rajasthan)

46 A cut-out representing the goddess Kali is pasted on to an electricity-meter board, with chalk demarcation lines depicting the altar. According to myth, the Mother Goddess Durga became a warrior to destroy the giant 'Asuras' (demons) who were wreaking havoc with the balance of the universe. The power of the demons had grown to such a degree that with each drop of blood spilled, there arose another demon. Unable to combat this force Durga took on the powerful shape of Kali, who moved through the universe with overwhelming power, literally 'licking' – or in other words absorbing within her – all the negative elements, thus restoring the cosmic balance. Kali encompasses within herself the powers of both creation and destruction. She is the symbol of eternal time, and the dynamic force of creation. She stands on the body of Shiva, who here represents the unmanifest. Her four arms show the two different aspects of her image. Two of her hands indicate the Abhaya (fear-removing) and the Vara (boon-granting) mudras (gestures); she holds a weapon in a third hand symbolizing the power of destruction, and a severed head in the fourth indicating that there is no escape from time. The garland of heads show that individual lives and deaths are transitory sequences in the continuum of eternal time. Generally, Kali in her terrifying aspect is depicted as black, the colour of the night into which all is dissolved, and she stands naked, which indicates the stripping away of illusion. She is shown here with colourful garments and with a blue hue. The artist seems to have combined the blueness of Krishna and the garments of Durga, creating his own vision of Kali, making her more approachable and loving, and invoking her protective and motherly aspects. (Bengal)

47 Folk-representation of Kali, painted on plastered stone. (Rajasthan)

48 Kali shrine of carved stone. (Rajasthan)

49 Goddess-image in a traditional workshop. (Bengal)

50 Clay goddess-heads, set out by the roadside to bake in the sun. (Bengal)

51 Sati-stone, a memorial to a female ancestor. (Gujarat)

52 Altar with sacred markings of Shiva's Trident (the Trisula), symbolizing creation, preservation and dissolution. The Trident also represents the three 'subtle' arteries of the body, Ida and Pingala, and Sushumna, through which the feminine energy ascends from the base of the spine to the summit of the head during meditation. The Trident is also the divine weapon of the deities, including the Mother Goddess Durga. It is used throughout India in rituals and ceremonies, for protection. (Rajasthan)

53 Symbol of Shiva's Trident with solar and lunar emblems at either side, symbolizing the polarities. (Rajasthan)

54 House-wall with an alcove dedicated to Shiva, and Trident-markings. (Rajasthan)

55 The Trident drawn on a temple wall. The 'sula' of 'Trisula' means a sharp instrument, a weapon of the gods. According to Coomaraswamy, the Trisula is a cosmic pillar that holds the earth and the heavens apart. (South India)

56 Shiva and Shakti (Goddess) shrine, with the Trident implanted in the ground. (Rajasthan)

57 Shiva-linga shrine with clusters of images covered with coloured foil representing the generative powers, concerned with fertility and the crops.(Rajasthan)

58 Shiva-linga shrine. Shiva, meaning auspicious and benign, is worshipped in many forms throughout India. He is known by the three names Shivan, Shiva, Shivam, representing male, female and neuter, creator, protector and destroyer – all in one. (Rajasthan)

59 The base of a tree is used as a shrine to symbolize the powers of growth and regeneration. The stone mound represents the male principle Shiva, the base, the female principle Shakti; with the fusion of these bi-polarities the whole process of creation begins. (Rajasthan)

60 Rock shrine with the Shiva Trident and offerings from travellers. (Rajasthan)

61 A painted stone image of Shiva in his folk-form Bhairon (Bhairava) has large 'all seeing' eyes that are ceremonially anointed at the time of consecration, giving the icon the 'gift of sight'. (Rajasthan)

62 Bhairava-image made of a sun-baked clay mound decorated with foil. (Rajasthan)

63 A priest performing a ritual at a roadside shrine of Shiva. (Gujarat)

64 A boy's initiation into manhood beside the River Ganges, with a yantra (power diagram) drawn on the ground. (Benares)

65 Icon of Nag, the Snake God, also called 'the Black One', beside two painted surfaces dedicated to the Mother Goddess, for protection. (Rajasthan)

66 In a wall-plaque the goddess is represented mounted on her animal vehicle. (Delhi)

67 Images of gods, goddesses and saints displayed in a local market. (Benares)

68 Popular icons for sale near a temple. (Bengal)

69 A carved stone depicts a legendary hero who bravely fought a snake and died, to be reborn as a

snake god. He is regarded as a protector from snake-bites, and many herdsmen and shepherds worship this image for the safety of their livestock. (Rajasthan)

70 A stone relief-tablet of Alaji is placed in the village square as a protective deity. The diagrams on the wall are of stepped yantras, with a radiating centre invoking the protective powers and demarcating the sacred space around the image. (Rajasthan)

71 Shrine of Surya-dev, the Sun God, with below, two elephants who guard and support the region. (Rajasthan)

72 Clay-relief of a local legendary hero renowned for his bravery. (Rajasthan)

73 Relief-tablet of stone dedicated to an ancestor, whose spirit is a guide and a protector of the family. (Gujarat)

74 Pots covered with vermilion-coloured fabric are placed on mounds of earth in a ritual performed to ensure conception and safe birth. The pot has been used as a fertility symbol since ancient times. A pot containing water or seed 'contains' the life-force and the protective powers of nature. Rituals are also performed to attract rain to generate new life in the earth. (Rajasthan)

75 Pathway shrine raised on three levels leading into an inner sanctuary. The Garbha-grha (womb-chamber) is a small dark room which enshrines the deity, and is the symbolic space within which the seeds of universal creation exist. The three levels symbolize the three Gunas (qualities) of Prakriti (nature or matter): Sattva (wisdom), Rajas (activity), and Tamas (illusion). The flag is a mark of authority and power. (Rajasthan)

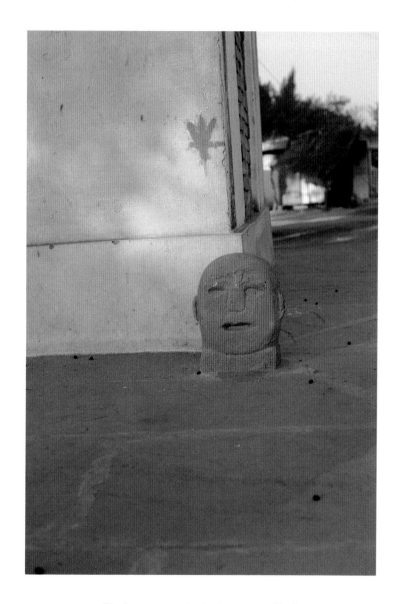

1 Bhairava, popularly known as Bhairon,
 guardian of the village boundary

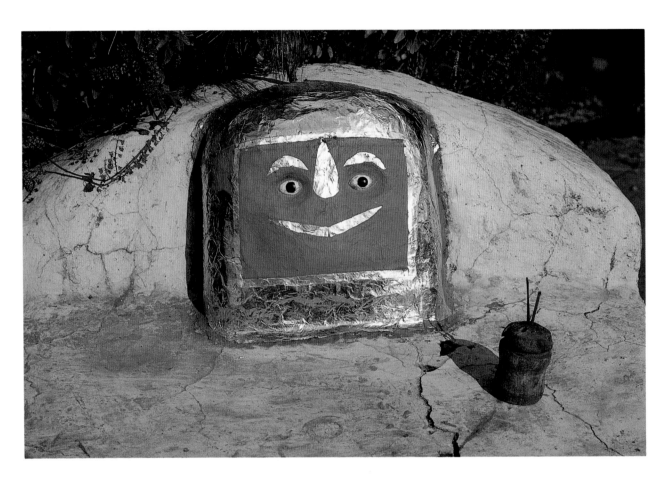

2 Poliaji, protector of travellers

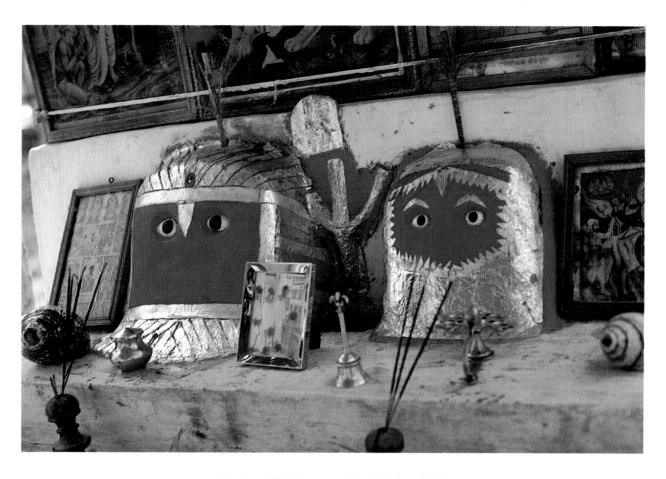

3 Shrine of Bhairava and the Mother Goddess,
with implements of worship and photographs

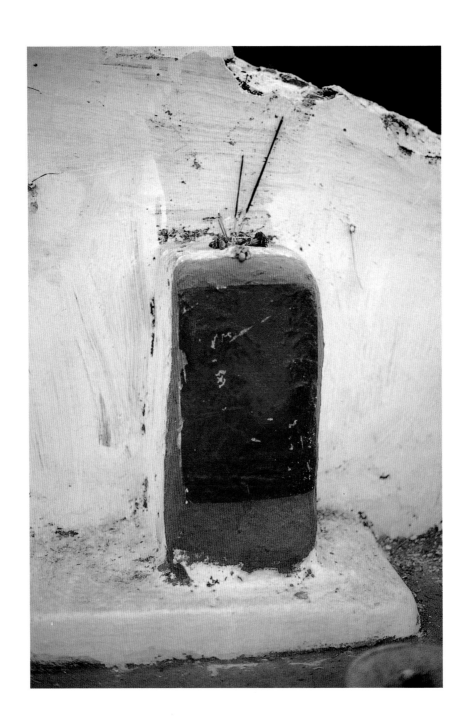

4, 5 Vermilion-smeared wayside Bhairava shrines

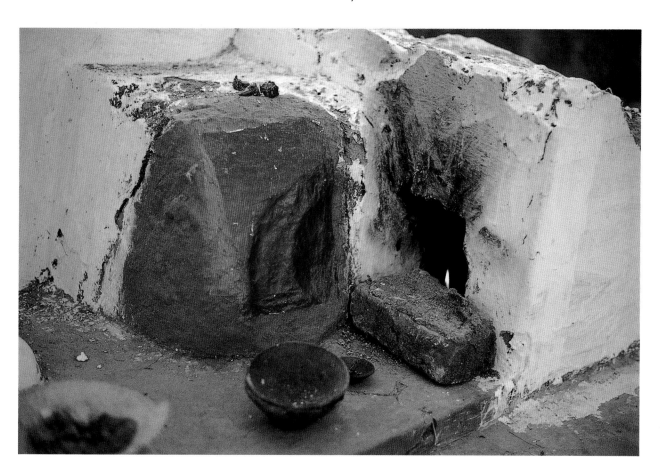

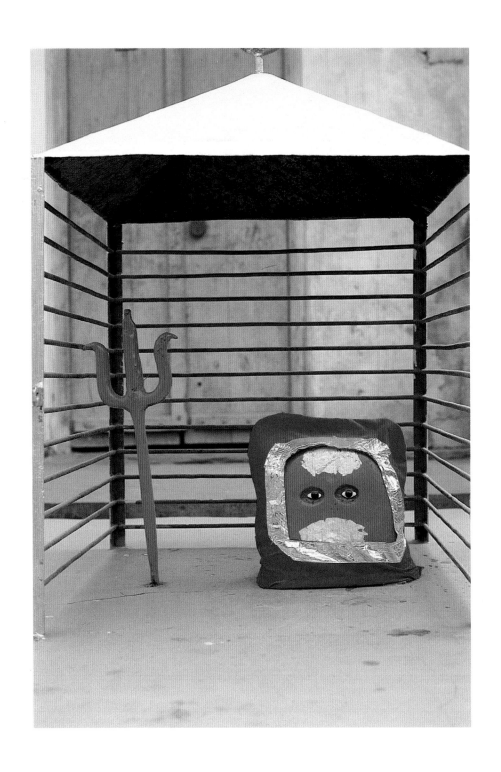

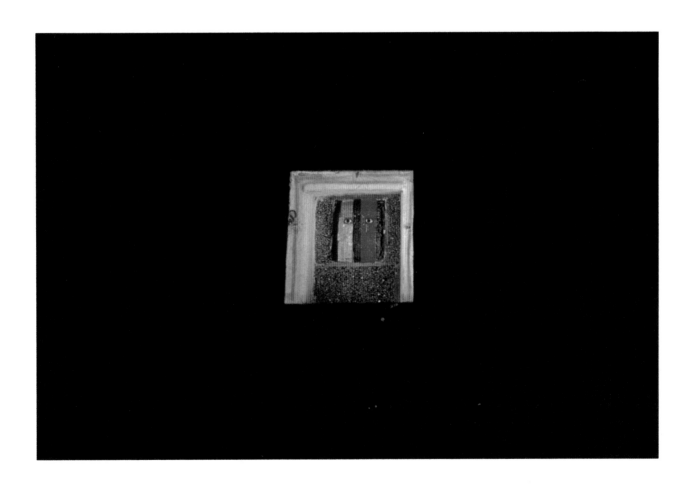

6 Bhairava-image with the Trident, the implement
of Shiva, the Great God of whom he is an aspect

7 Shiva-image with three stripes, symbolizing creation,
preservation and dissolution, and two halves representing the
positive and negative energies

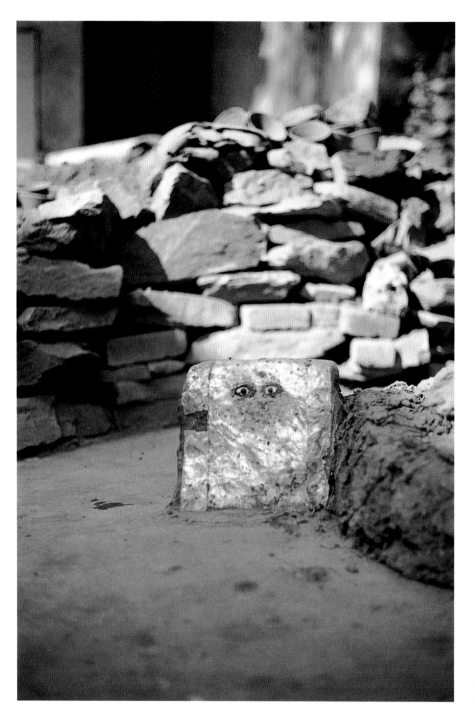

8 A folk-form of Shiva, 'keeping an eye' on the village

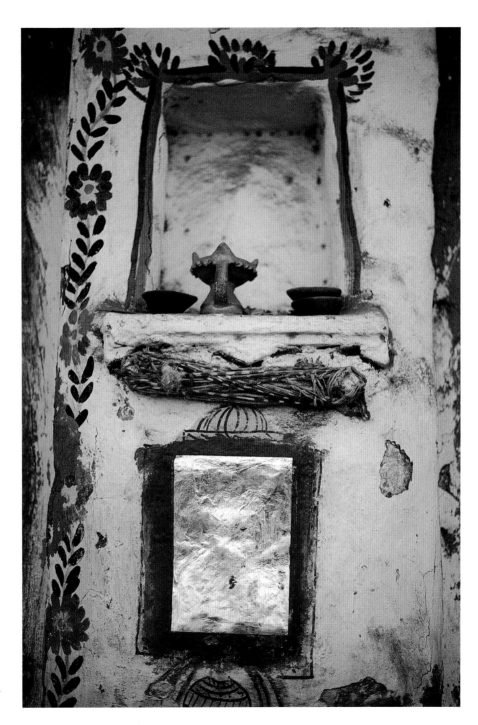

9　An abstract image of Bhairava
as the guardian of the shrine

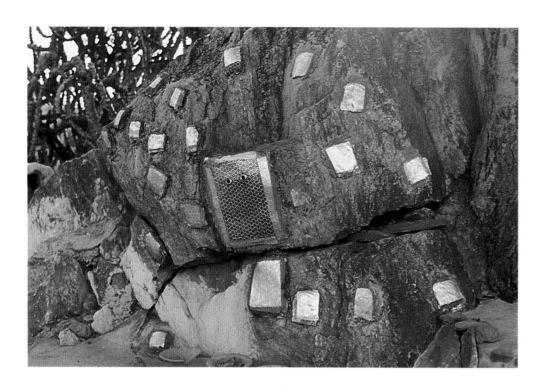

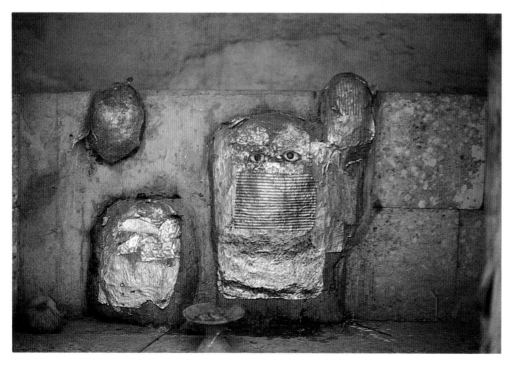

10–13 Bhairava-images and square patches of foil, each of which is an individual offering

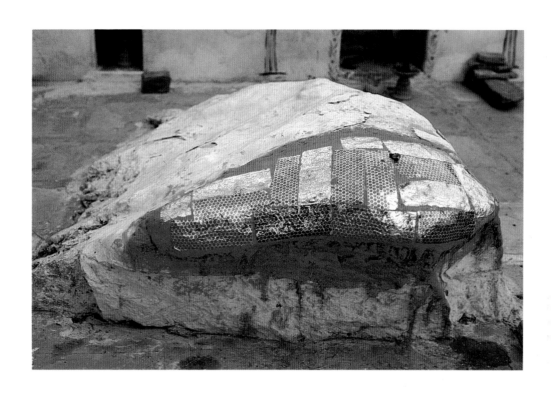

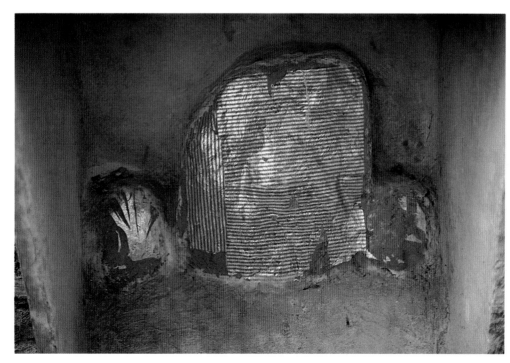

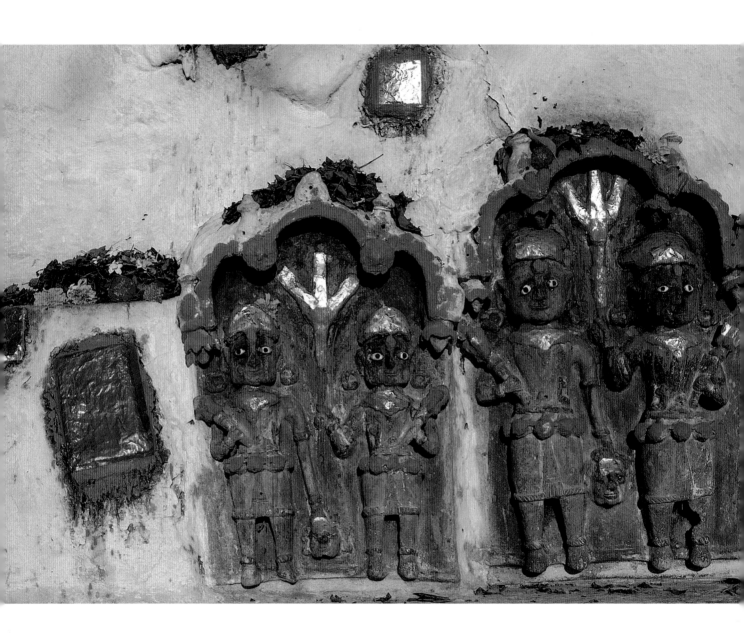

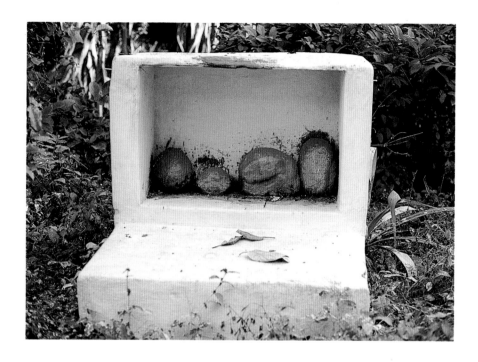

14, 15 Opposite, representational
Shiva-images with the Trident; above, ritual stones
dedicated to Bhairava

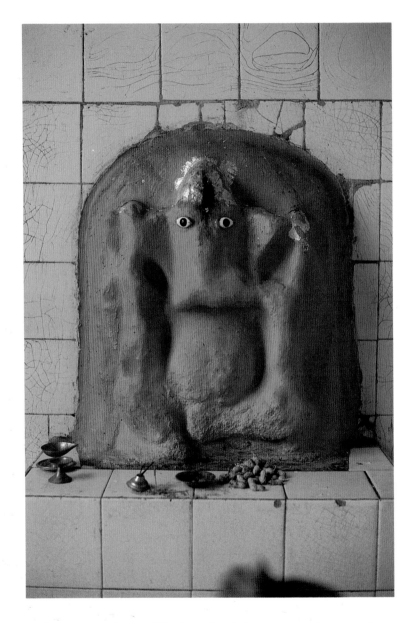

16, 17 Ganesha, the 'elephant-headed one', worshipped as the
embodiment of success, prosperity and peace, but above all, as
the remover of obstacles

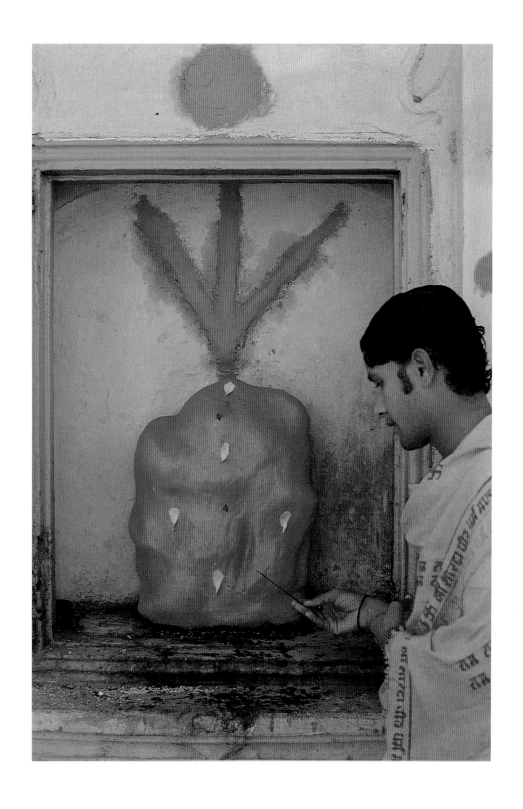

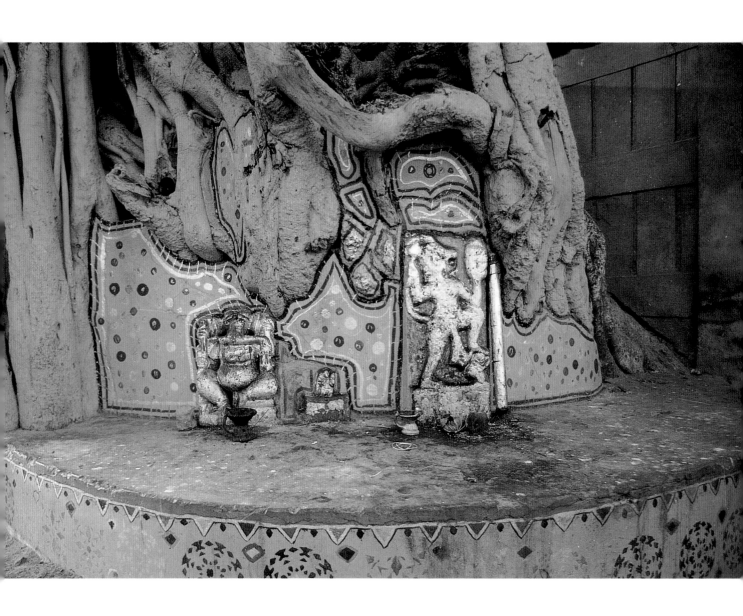

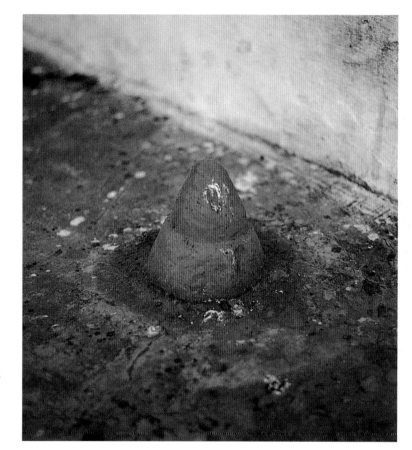

18 Opposite, the base of a tree painted as a shrine of Ganesha (left) and the Monkey-god Hanuman (right)

19 Beehive-shaped icon as a protective spirit in a courtyard where wrestlers train. The 'sacred sound' of red, its colour, is *Rama*, which is also the mantra of the Monkey-god Hanuman, the heroic figure of the *Ramayana* epic

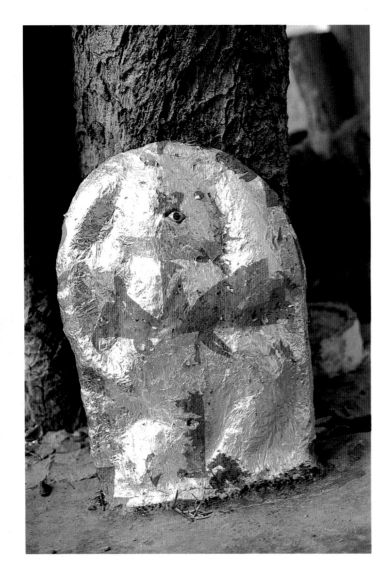

20, 21 Left, a one-eyed Hanuman as
village guardian; and opposite, with
solar and lunar symbols

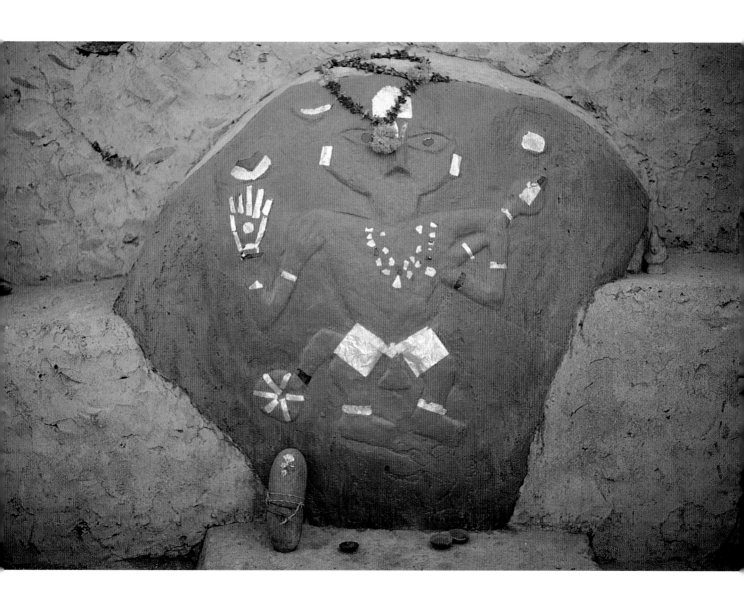

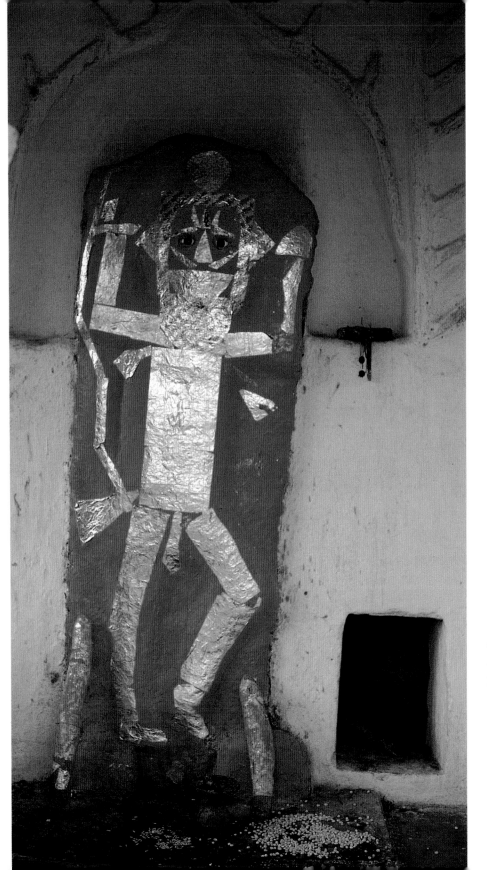

22, 23 Images of Hanuman with a mace, and with both arms raised in a gesture of protection

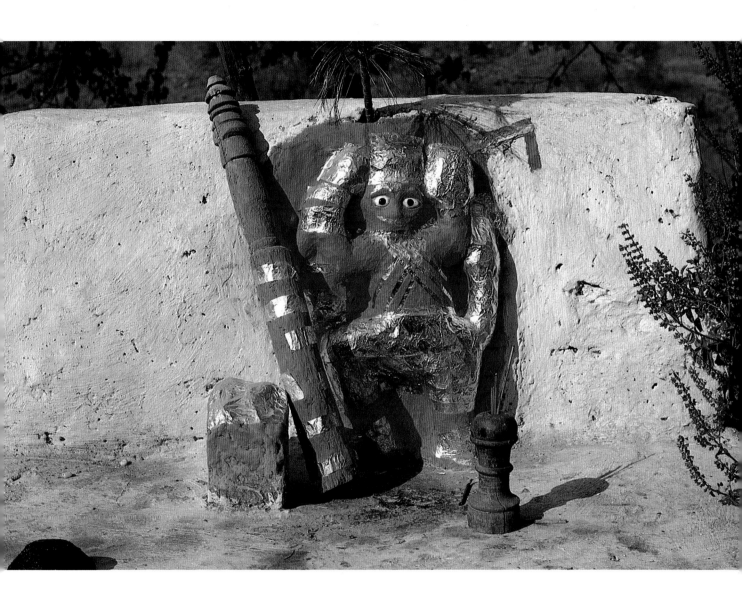

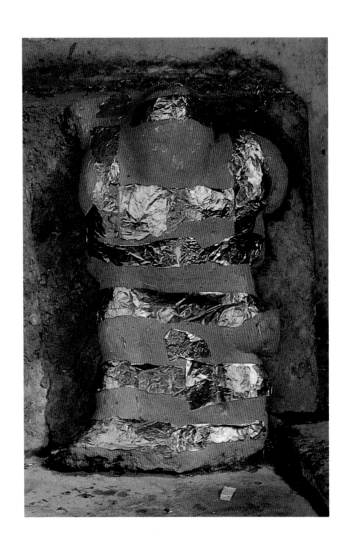

24–26 Hanuman as protector of the temple, left,
and in a courtyard used by wrestlers, right. Opposite,
an image emphasizing strength and power

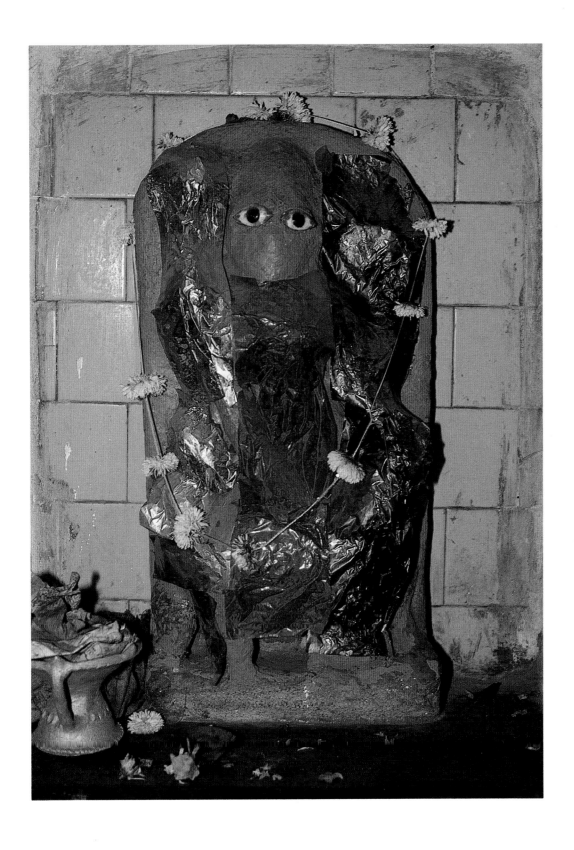

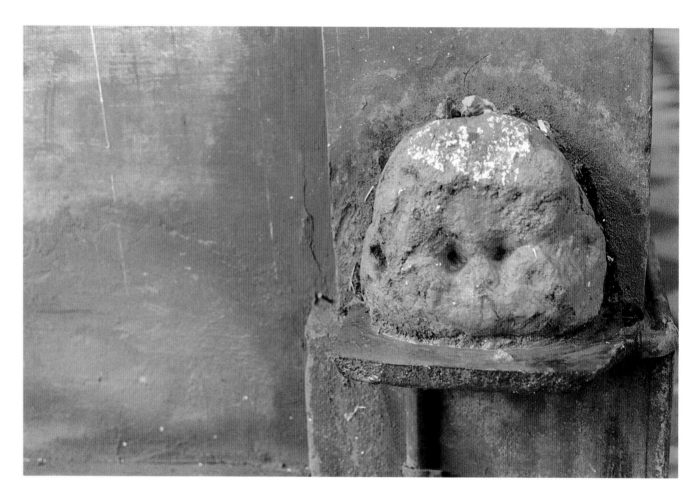

27 Hanuman the 'heavy-jawed one'

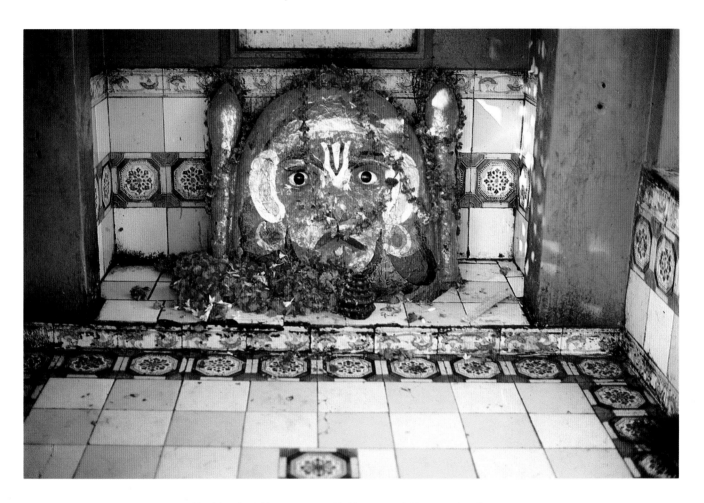

28 Head of Hanuman with the sign of the mantra *Rama* on
the brow

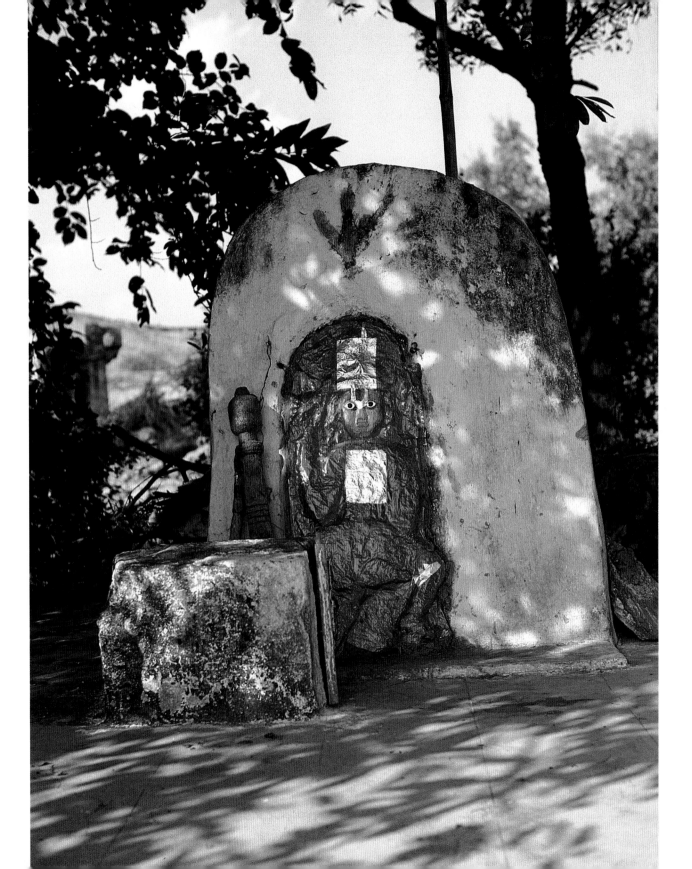

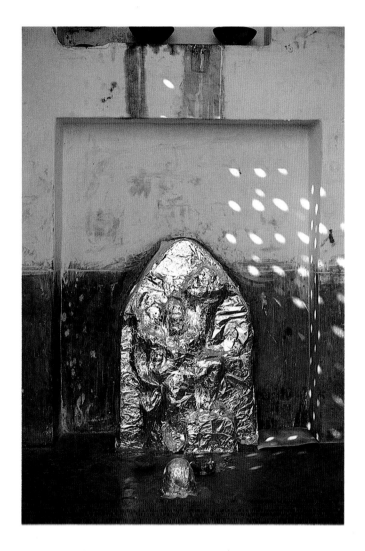

29, 30 Opposite, Rama, the hero of the *Ramayana*, a prince of 'moon-like' beauty. He is seated with his hand raised in blessing, and his heart indicated by a square of foil. Above, a foil-covered shrine of Hanuman

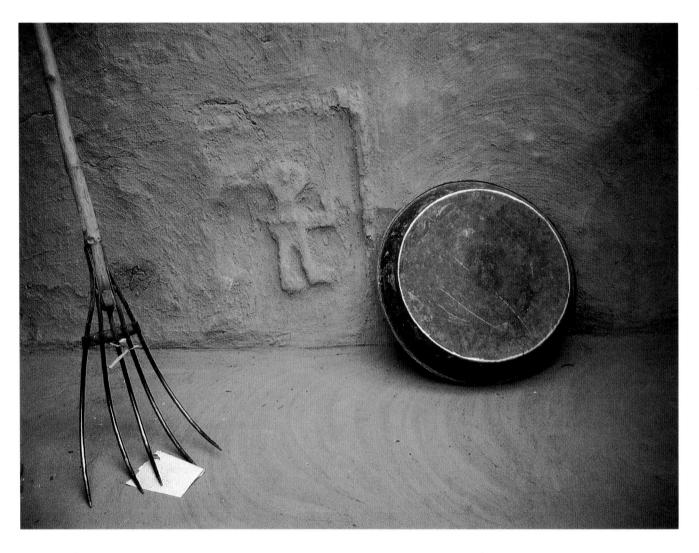

31　Rama-image on a courtyard wall

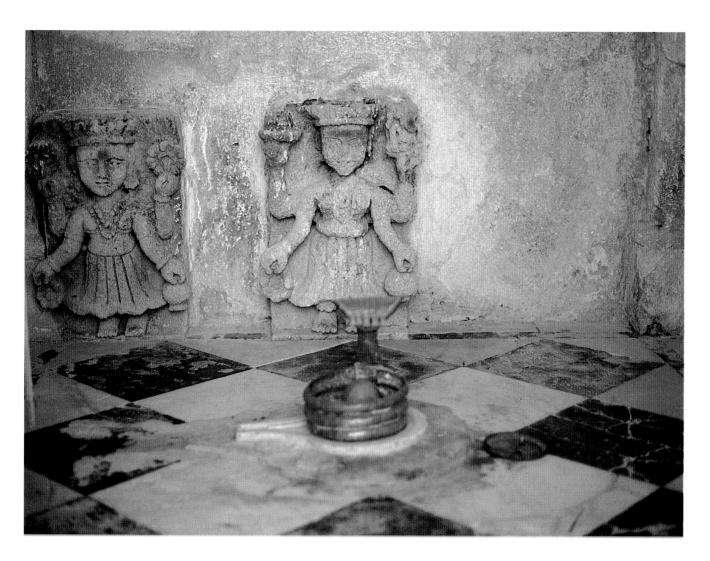

32 Images of the Great God Vishnu facing an altar of Shiva

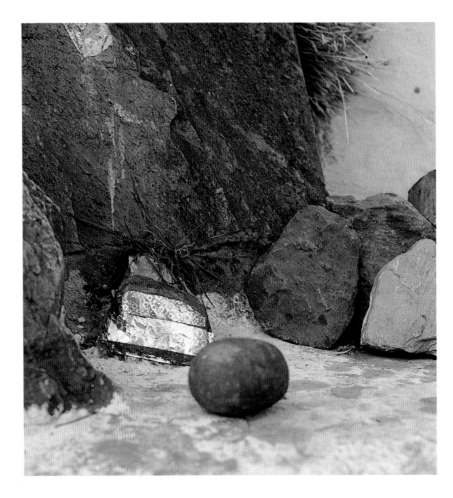

33 Stone representing Vishnu as cosmic energy

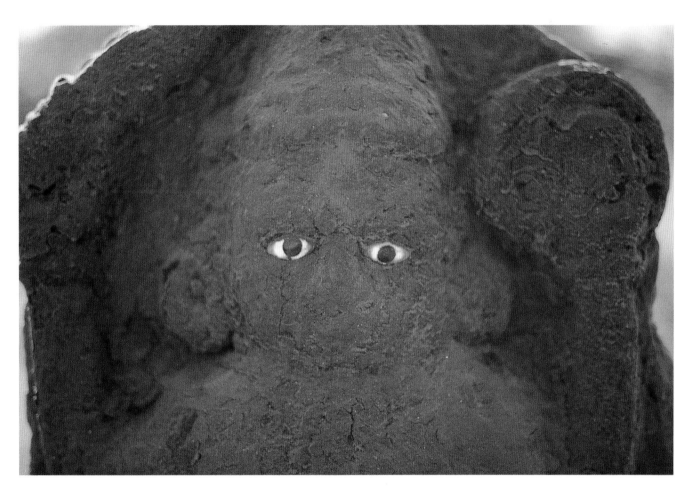

34 Image of Vishnu, the preserver of the universe

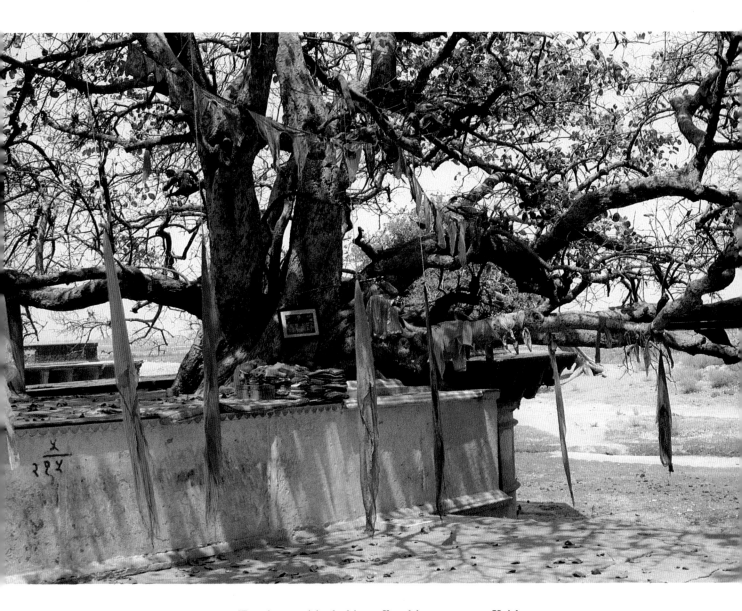

35 Tree hung with clothing offered by women to Krishna, a
divine incarnation of Vishnu, who lived as a village youth, and
stole the saris of the cowherd-girls

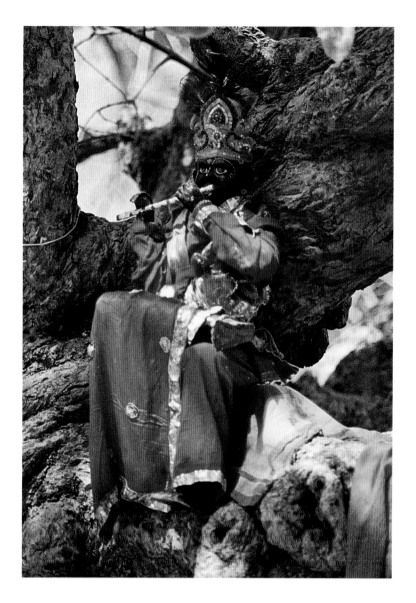

36 Krishna, who by his flute-playing attracts all to himself

37　Krishna as Hari, the stealer of hearts, painted at the entrance to
a roofless wayside enclosure

38 Guardian angel suspended above a goddess shrine

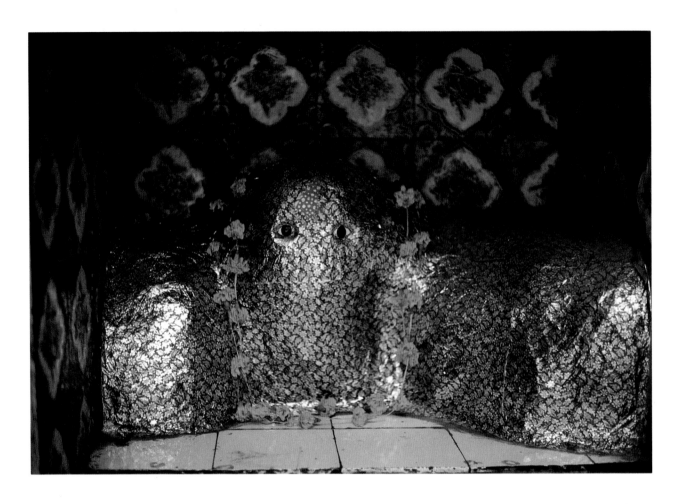

39, 40 Above, a group of goddess-images;
opposite, a goddess-image visited by childless women

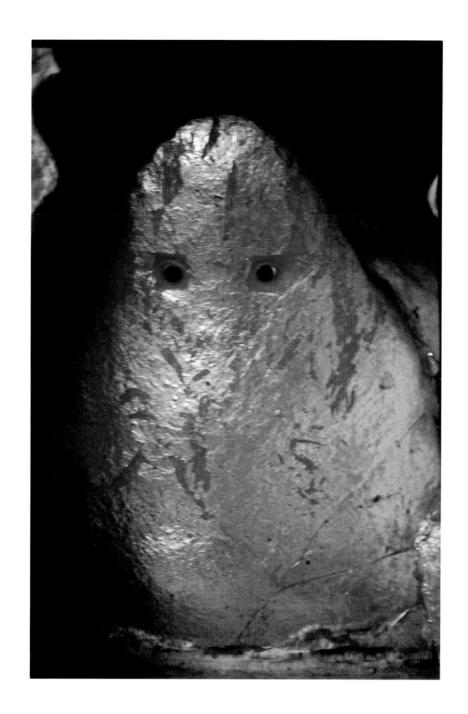

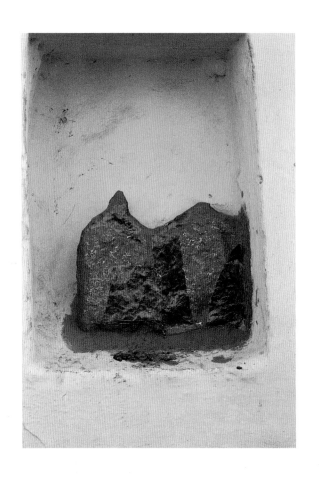

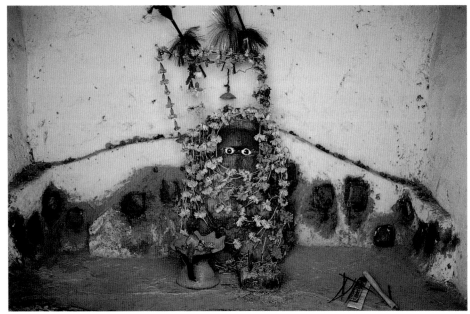

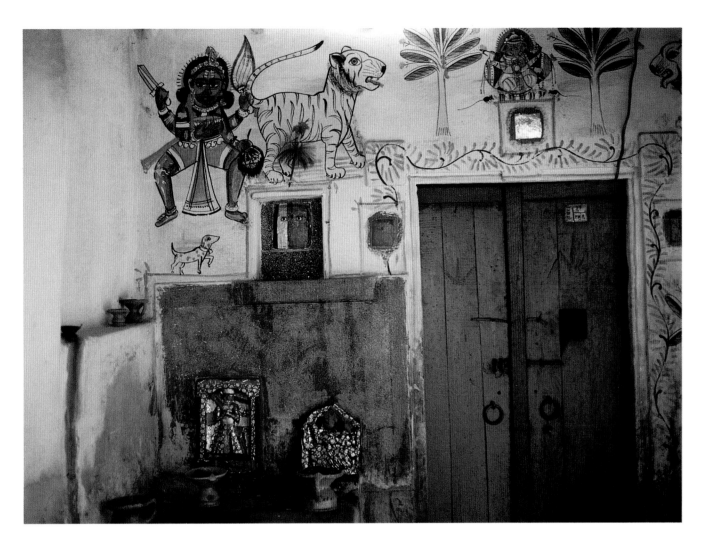

41–43 Opposite, above, abstract image of the
Goddess and all the female powers; opposite,
below, garlanded goddess-image; above, the fierce
form of the Goddess as Chamunda, depicted with
her tiger vehicle guarding a Shiva shrine

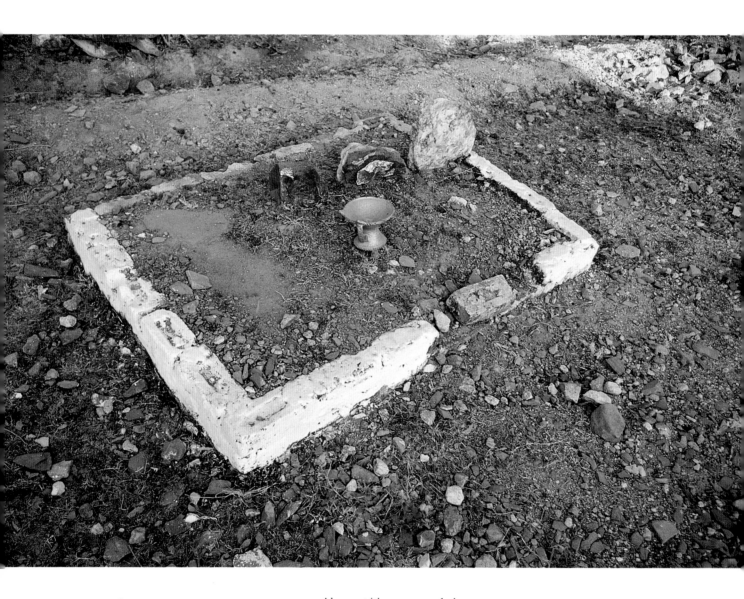

44, 45 Above, *pitha*, or sacred site;
opposite, a garlanded goddess shrine

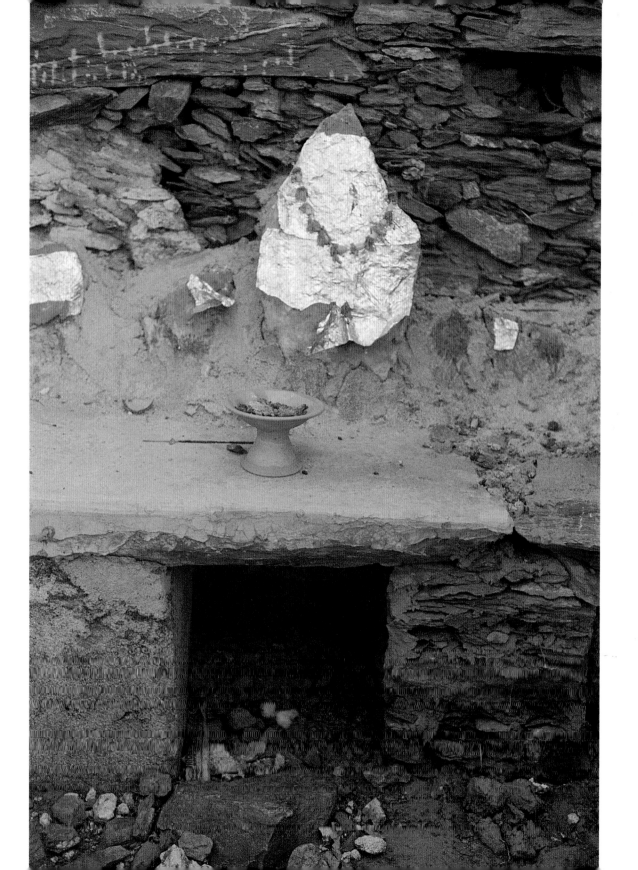

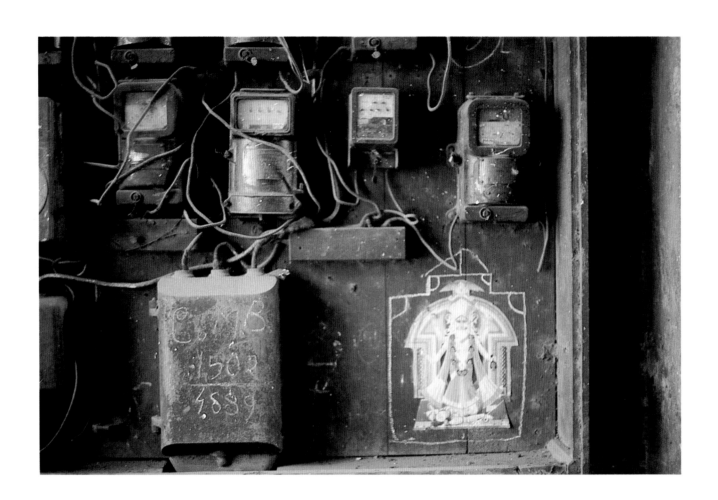

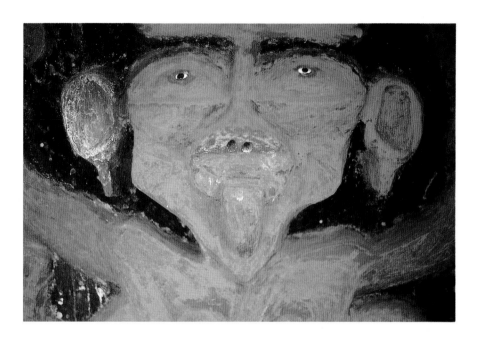

46, 47 Images of the goddess Kali, the terrifying aspect of the
Great Goddess Durga, representing the powers both of creation
and destruction

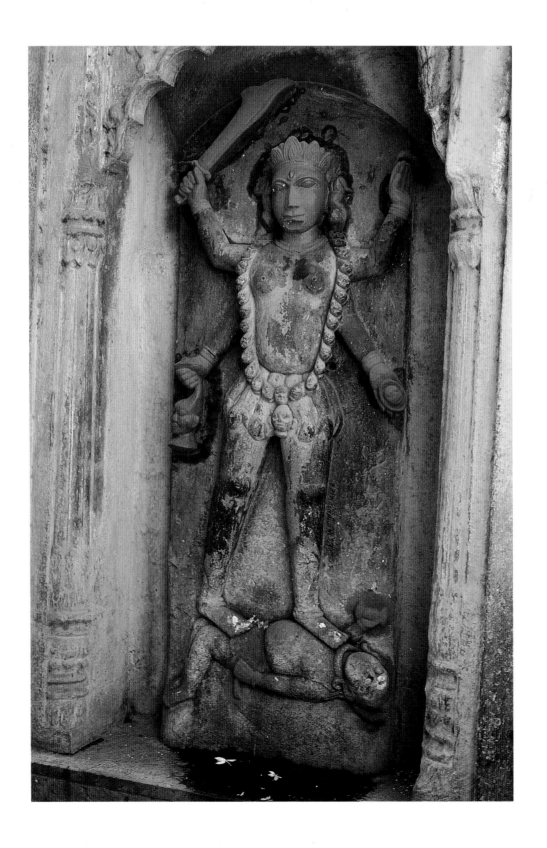

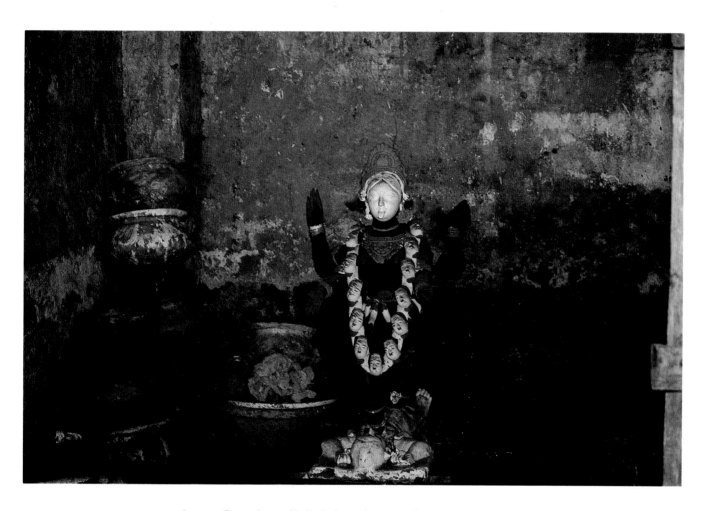

18, 19 Opposite, a Kali shrine; above, an image of Kali in a
traditional workshop

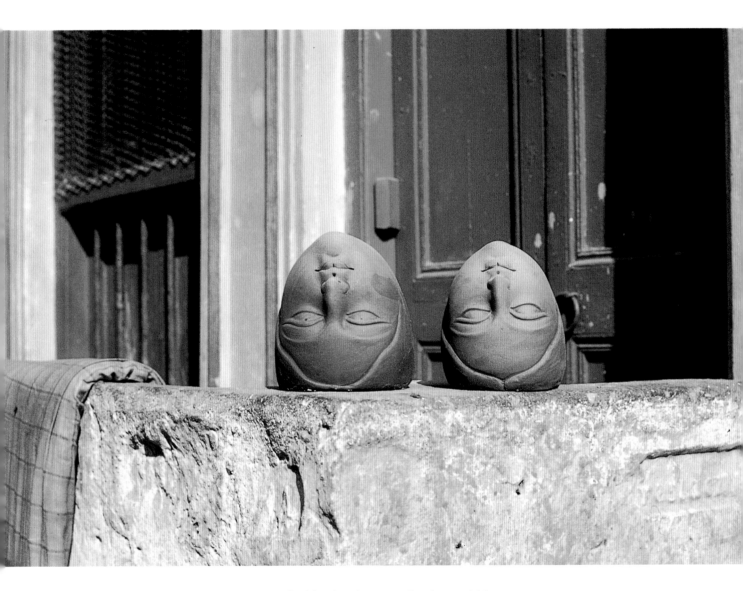

50 Goddess-heads set out by the roadside
to dry in the sun

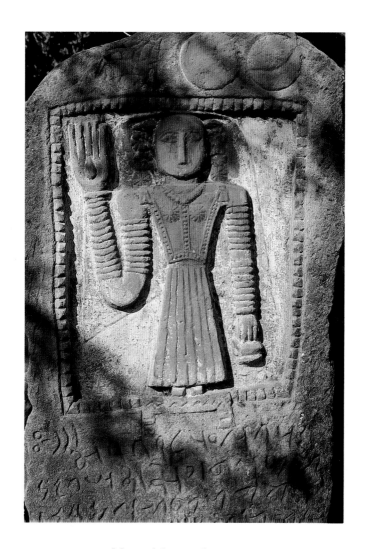

51 Memorial stone for an ancestor

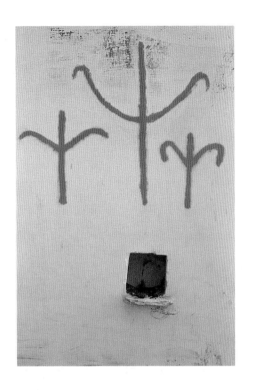

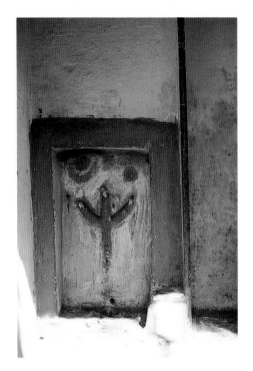

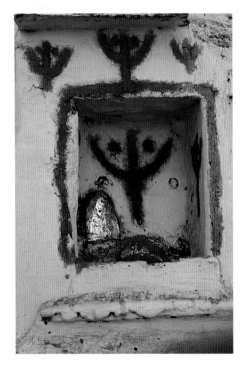

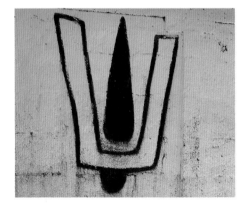

52–56 The Trident of Shiva, the
divine weapon of the deities, including
the Mother Goddess, Durga

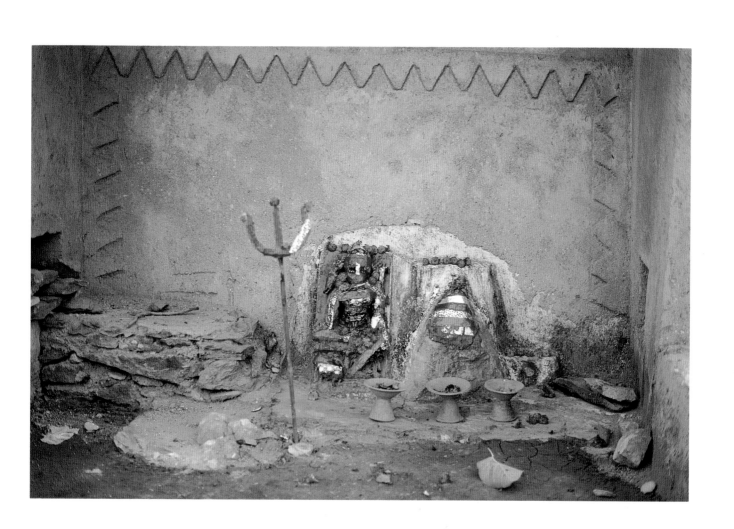

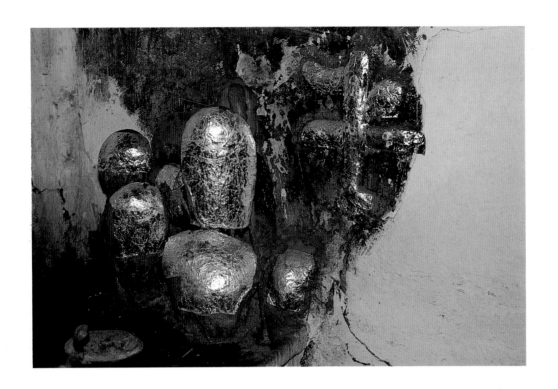

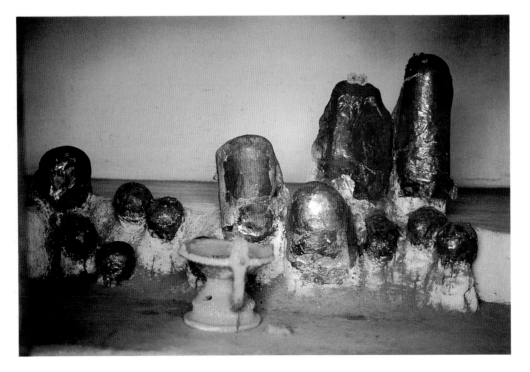

57, 58 Shiva-linga shrines with clusters of linga, concerned with fertility, but also representing male, female and neuter, creator, protector and destroyer: all in one

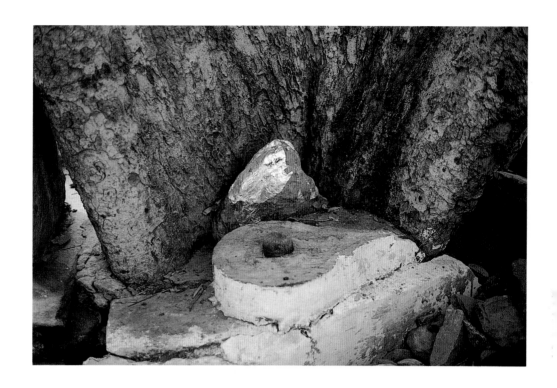

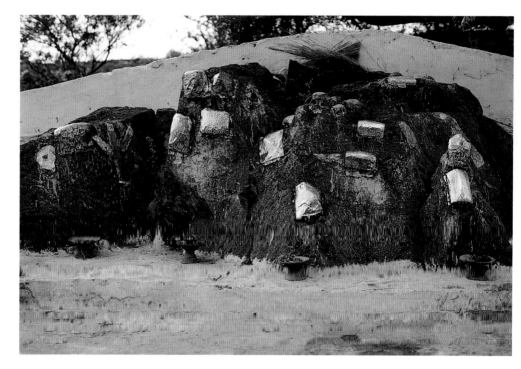

59 Shrine of Shiva and Shakti, male and female principles, placed at the base of a tree to symbolize growth and regeneration

60 Shiva rock-shrine with offerings by travellers

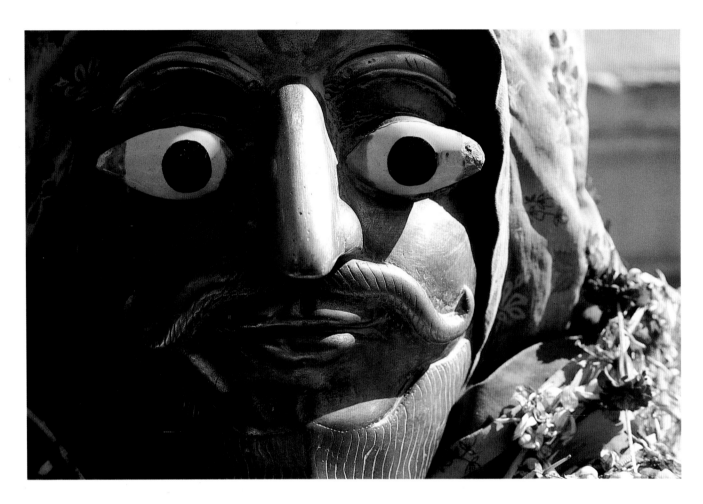

61 Shiva as Bhairava, with all-seeing sacred eyes

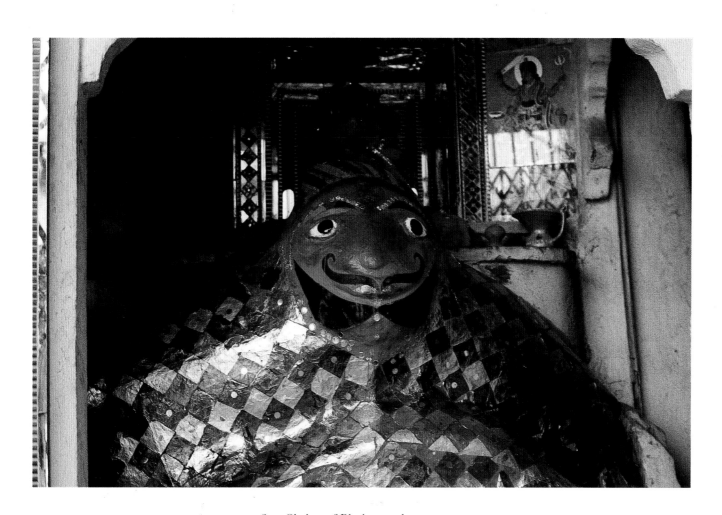

62 Shrine of Bhairava, the protector

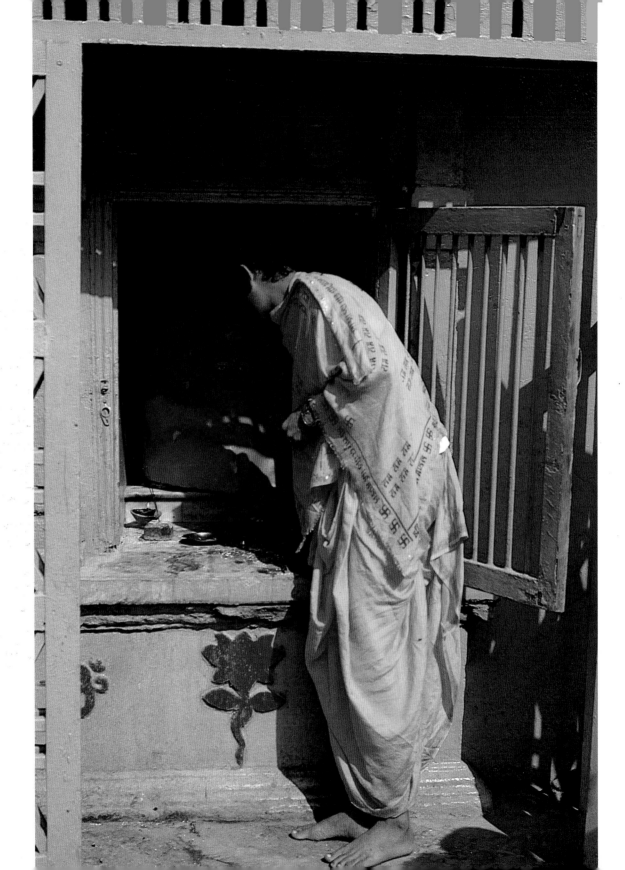

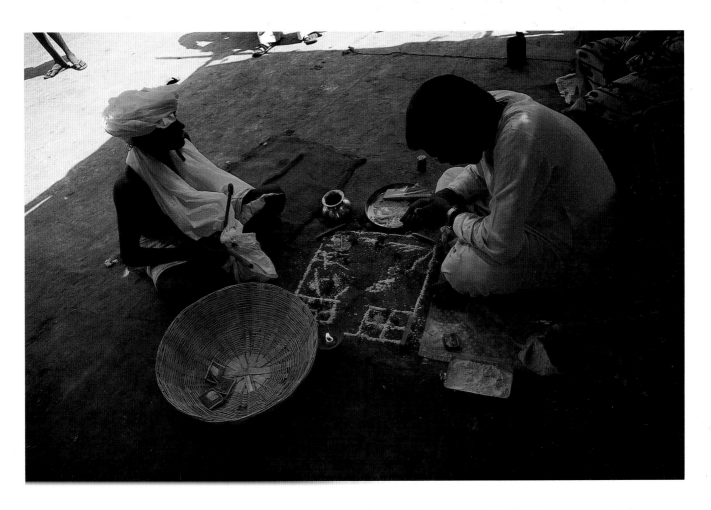

63, 64 Opposite, a priest performs a ritual at a shrine of
Shiva. Above, the rite of initiation being performed with a
yantra (sacred diagram)

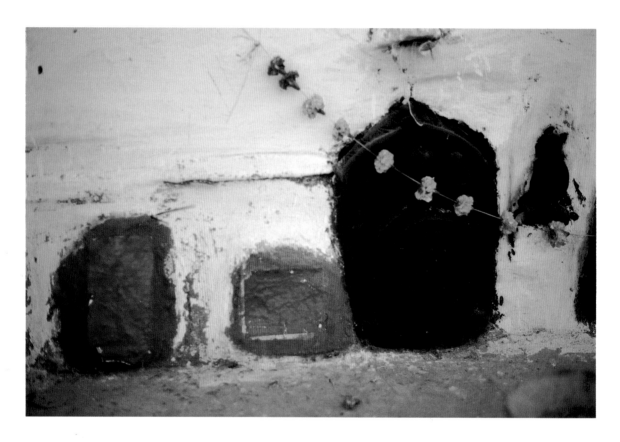

65 Shrine of the Snake God and the Mother Goddess

66 Opposite, image of the Goddess on her animal vehicle,
with a devotee's garland

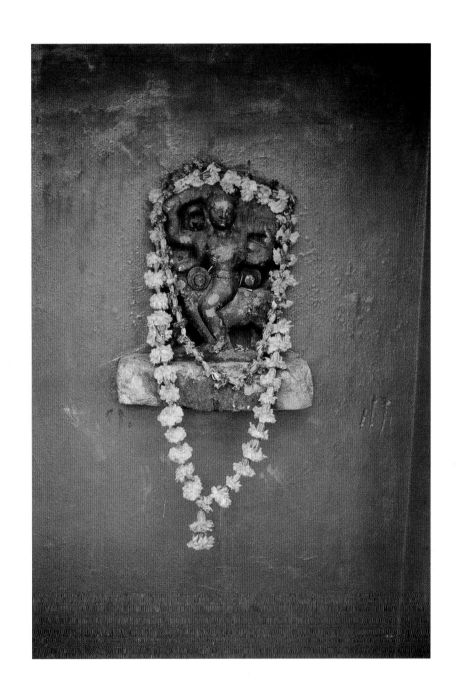

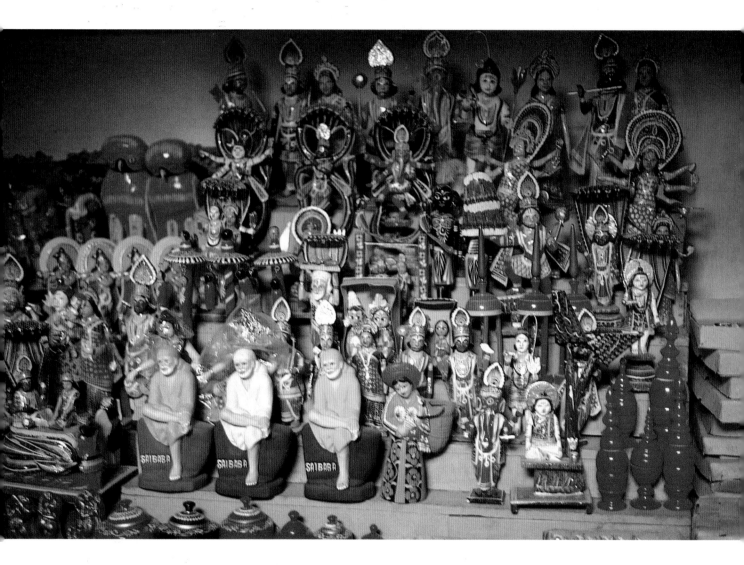

67, 68 Popular icons of gods, goddesses and saints
for use in household worship

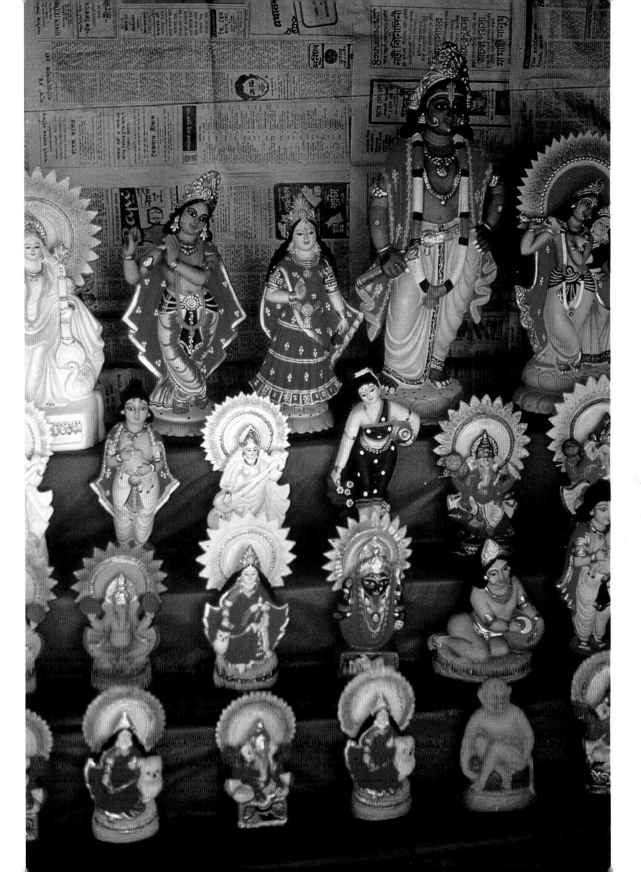

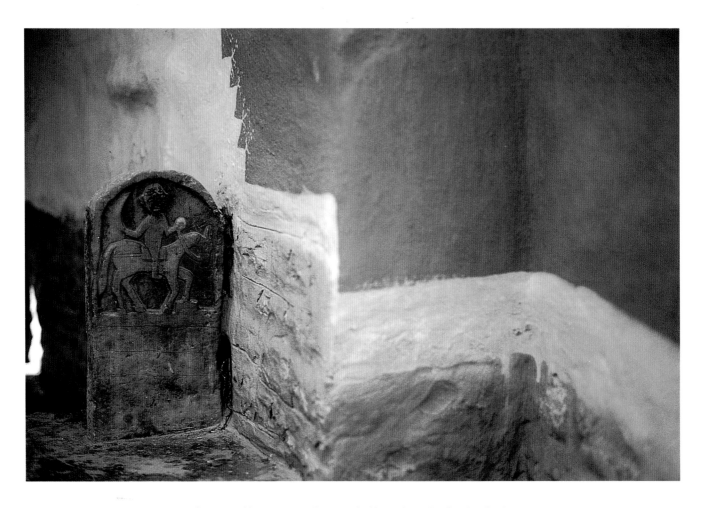

69, 70 Above, carved stone dedicated to the Snake God,
protector against snake-bites; opposite, the protector-deity Alaji
and stepped yantras in a village square

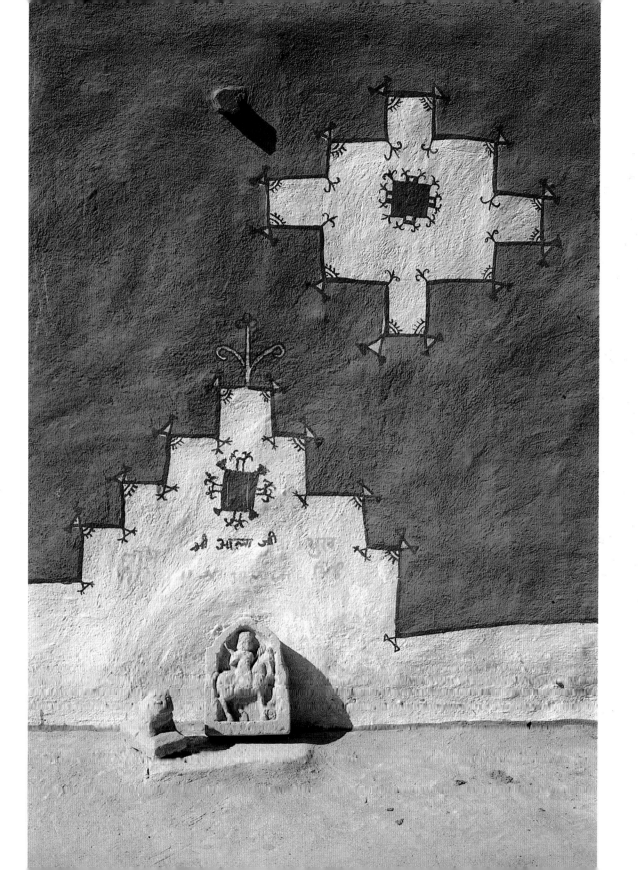

श्री आल्हा जी

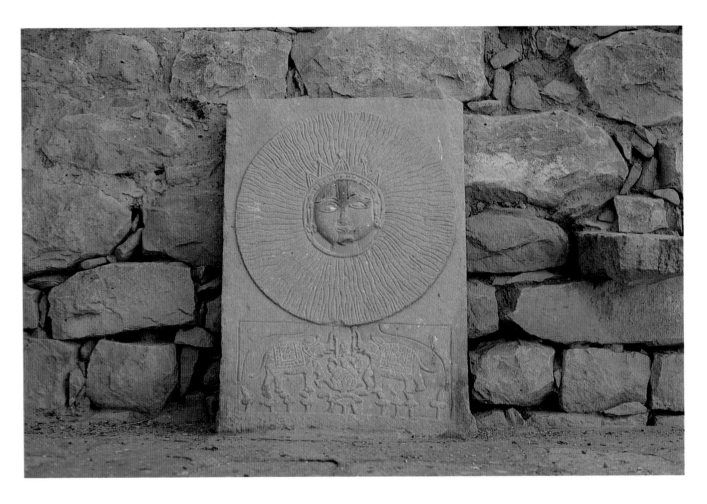

71 Sun God shrine with two guardian elephants,
one at either side below

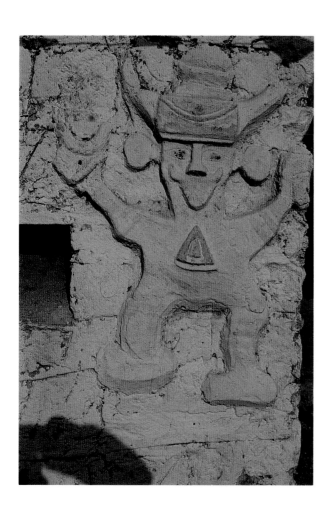 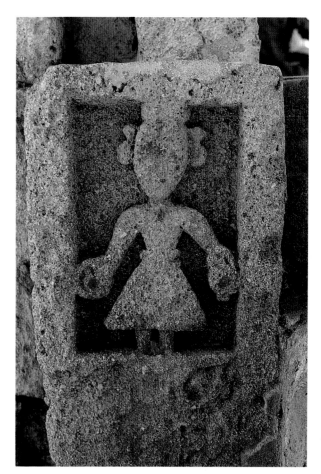

72, 73 Figures of a legendary hero, left, and a
female ancestor, right

74, 75 Above, pots placed on earth mounds and covered with vermilion cloths, representing the life-force and the protective powers of nature. Opposite, a shrine with three levels leading to a small dark inner chamber, symbolic container of the seeds of universal creation

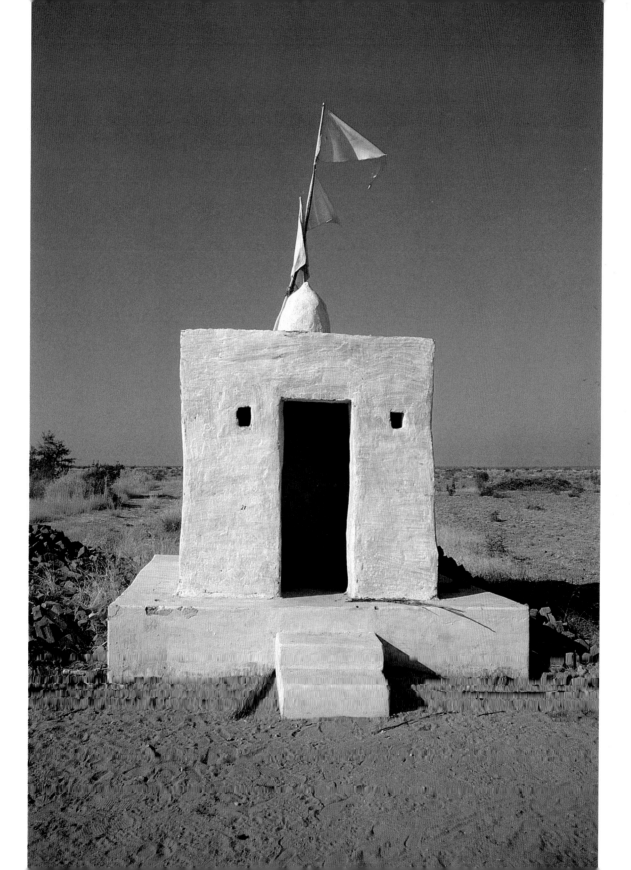

Acknowledgments

I would like to thank my father Ajit Mookerjee
for his help and cooperation; my mother Sudha, who awakened a deeper
awareness of things both within and around me; and Mangla Sharda
for her support and suggestions, without which this book
would not have taken its present form.